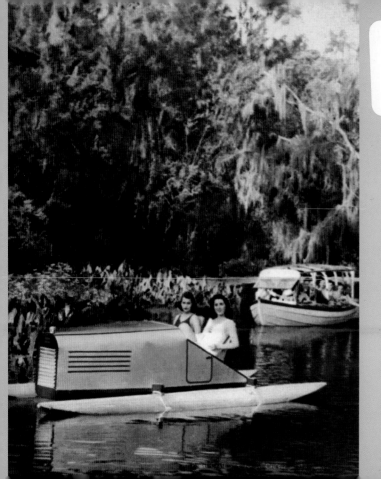

SEASIDE PUBLISHING

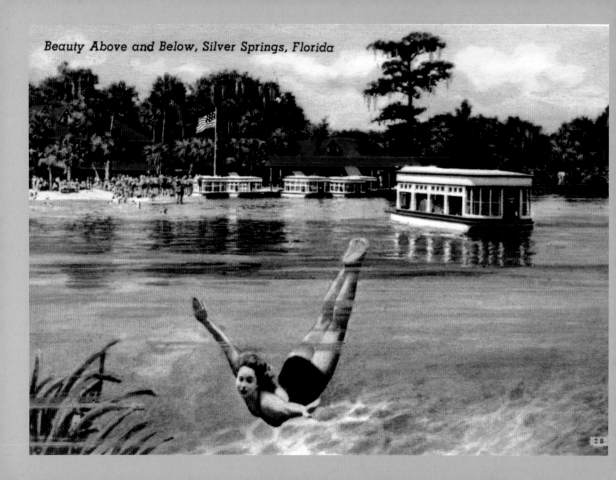

Beauty Above and Below, Silver Springs, Florida

Remembering

Florida Springs

Tim Hollis

Seaside Publishing
Gainesville · Tallahassee · Tampa · Boca Raton
Pensacola · Orlando · Miami · Jacksonville · Ft. Myers · Sarasota

For information about permission to reproduce selections from this book, write to Permissions, 15 Northwest 15th Street, Gainesville, FL, 32611-2079.

Printed in Korea on acid-free paper

21 20 19 18 17 16 6 5 4 3 2 1

Library of Congress Control Number: 2016937393

ISBN 978-0-942084-54-2

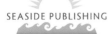

SEASIDE PUBLISHING

Seaside Publishing is a division of the University Press of Florida.

For a complete list of Seaside books, please contact us:
Seaside Publishing
15 Northwest 15th Street
Gainesville, FL 32611-2079
1-352-392-6867
1-800-226-3822
orders@upress.ufl.edu
www.seasidepublishing.com

Contents

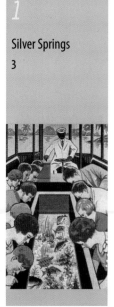
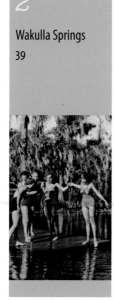
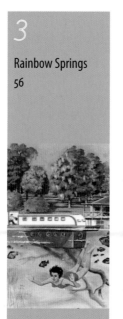

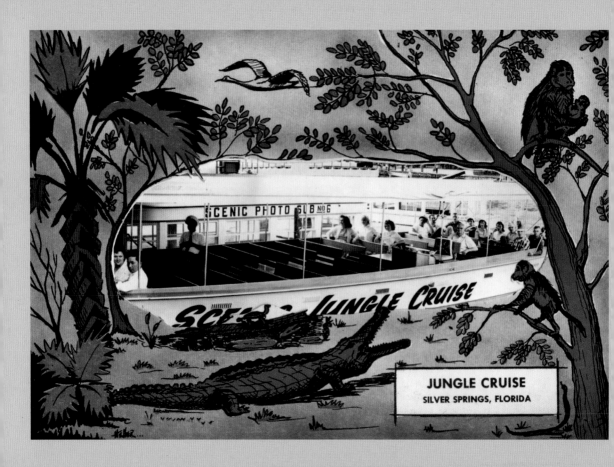

SCENIC PHOTO SUB NO 6

SCENIC JUNGLE CRUISE

JUNGLE CRUISE
SILVER SPRINGS, FLORIDA

Acknowledgments

Much of the material in this book came from the author's personal collection of photos and memorabilia. Additional photos and information were contributed by Ken Breslauer; Mary Darlington; Ginger Stanley Hallowell; Homosassa Springs archives; Melody May; Delee Perry; Rainbow Springs archives; Bill Ray; Silver Springs archives; Val Valentine; Wakulla Springs archives; Weeki Wachee archives; and Barbara Wynns.

Introduction

Although there is little question that Florida was, is, and always will be the nation's most celebrated tourist destination, a case could be made that many of its attractions can also be found in other states. Beaches? Practically any state with even a few miles of coastline will have one. Theme parks? They were invented in California. Goofy miniature golf courses? They began in Tennessee and spread across the country. What Florida had that could not be duplicated by other states was its vast number of springs and the subtropical jungle surrounding them.

In this small book we are going to look briefly at what became the "big five" of Florida's commercially developed springs: Silver Springs, Wakulla Springs, Rainbow Springs, Weeki Wachee Spring, and Homosassa Springs. Naturally, over the decades, other springs have been discovered and developed, but none of them came near to being the heavily promoted mini theme parks that these were. Each had its own unique selling points, but as we shall see from the postcards and other relics that document their pasts, there were also many elements they shared with each other.

This book provides only a brief history of these attractions. For those who wish to examine the subject in depth (without diving headfirst into the

springs' depths), there are several excellent books that have much to offer. Those include *Silver Springs: The Underwater Photography of Bruce Mozert* by Gary Monroe; *Weeki Wachee, City of Mermaids* by Lu Vickers and Sara Dionne; *Weeki Wachee Mermaids: Thirty Years of Underwater Photography* by Lu Vickers and Bonnie Georgiadis; and—if you can locate a copy—Yours Truly's long-ago take on the subject, *Glass Bottom Boats and Mermaid Tails: Florida's Tourist Springs*.

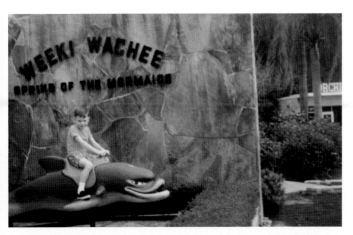

Author Tim Hollis hung out with retired prop Adolph the Porpoise during his first visit to Weeki Wachee Spring in 1969. Not surprisingly, some of the material in this book was collected on that same long-ago vacation.

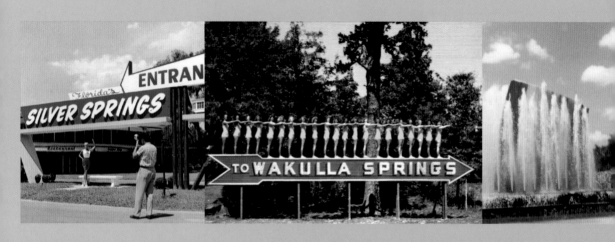

Remembering Florida Springs

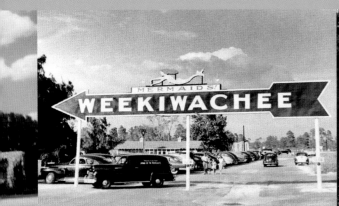
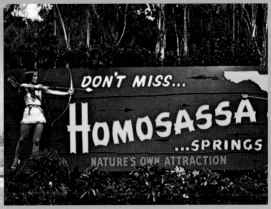

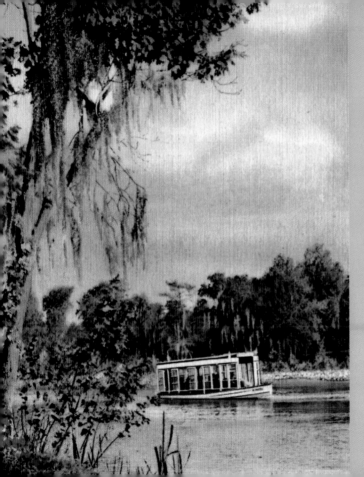

1

Silver Springs

Since prehistoric days, the area around what would come to be known as Silver Springs was a destination for both Native Americans and explorers alike. In the years immediately following the Civil War, another class of visitor arrived: the tourist. The difference between those and the millions who would eventually flock to Silver Springs was that the first tourists had to be transported by boats since there were no roads that led to the scenic spot. In the early twentieth century, the barely emerging automobile tourism industry discovered Silver Springs, and the garden spot east of Ocala would never see the end of it.

Even though Silver Springs had been drawing Florida tourists by boat and railroad since the 1800s, it was when business-men William Carl Ray (*seated*) and W. C. "Shorty" Davidson acquired the property in 1924 that it truly began its rise as the undisputed king of the state's roadside attractions.

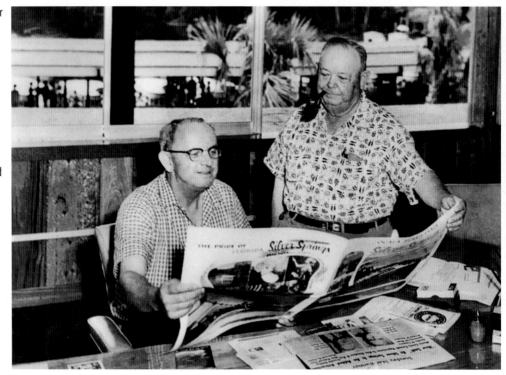

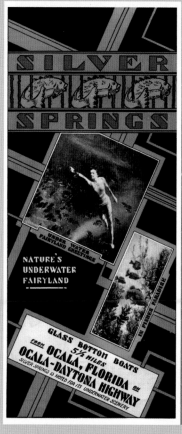

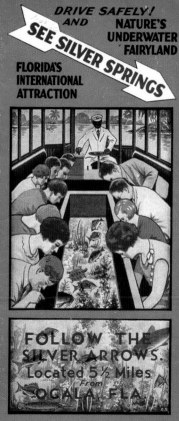

These early brochures illustrate the way the team of Ray and Davidson promoted Silver Springs in the early years. The archaic-looking purple and green one dates from circa 1928; the orange and blue one is from 1934 and mentions the "silver arrows" that served as directional markers along the Florida highways.

It is quite possible that the "See Silver Springs" arrows were the inspiration for the even more prolific "See Rock City" signs of a few years later. This illustration comes from a 1935 postcard folder, by which time Silver Springs was already the primary Florida tourist destination.

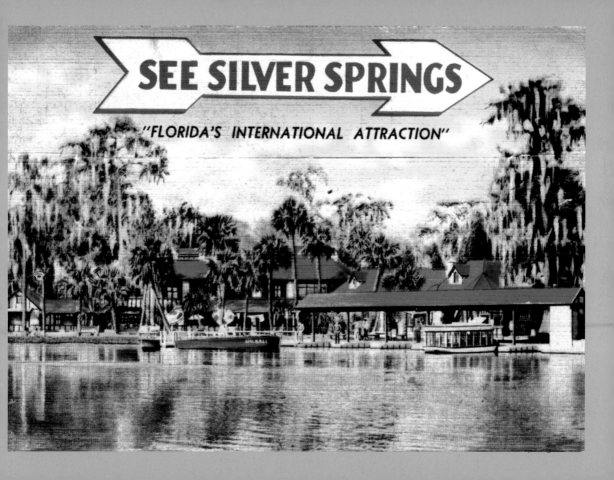

The exact origin of Silver Springs' glass bottom boats has been the subject of numerous conflicting legends. What is certain is that they were the attraction's primary (if not only) asset when Ray and Davidson took over. The boats' transparent wells joined forces with the clarity of the water to give visitors an unprecedented view into the undersea world.

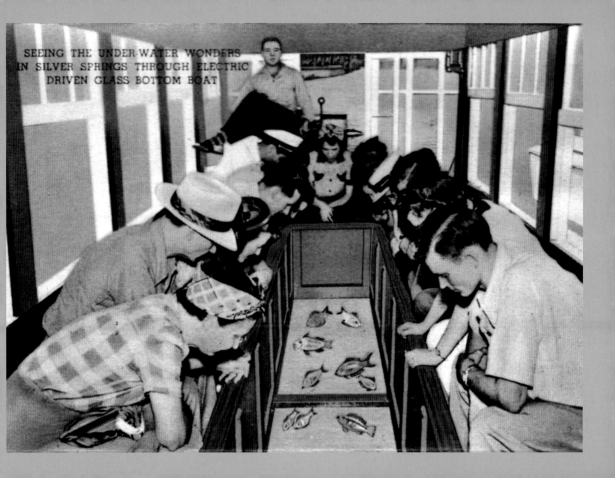

SEEING THE UNDER-WATER WONDERS
IN SILVER SPRINGS THROUGH ELECTRIC
DRIVEN GLASS BOTTOM BOAT

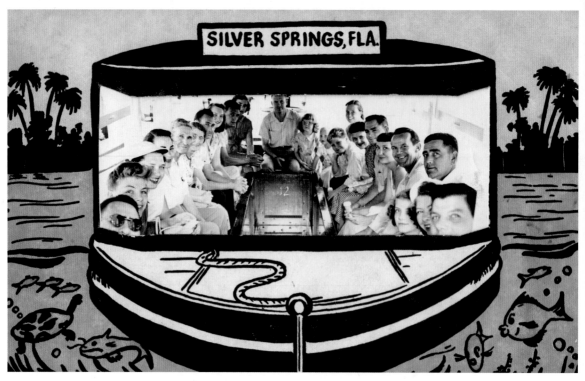

Since each glass bottom boatload of tourists had one of these souvenir photos taken, and then made available in a decorative holder, these are among the most common Silver Springs souvenirs to be found. The design of the holder changed quite often.

Linen postcards of the 1930s were made by taking black and white photographs and having a staff of artists retouch them in color. The resulting images, such as this one titled "Sunset at Silver Springs," often employed bright coloration never seen in nature.

SHRINE OF THE
WATER GODS

HISTORICAL ACCOUNT OF
SILVER SPRINGS, FLORIDA
LOCATED AT THE HEAD OF BEAUTIFUL SILVER RIVER
By Carita Doggett Corse

SHRINE of THE
WATER GODS

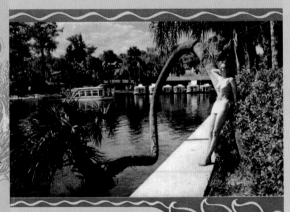

Historical Account of
SILVER SPRINGS, FLORIDA
LOCATED AT THE HEAD OF BEAUTIFUL SILVER RIVER
by Carita Doggett Corse
AUTHOR · LECTURER · HISTORIAN

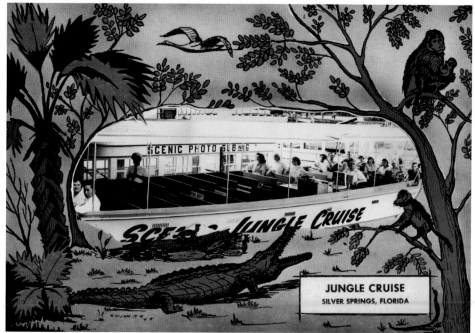

JUNGLE CRUISE
SILVER SPRINGS, FLORIDA

The Silver Springs Jungle Cruise was added in the 1930s by a concessionaire named Colonel Tooey. Yes, "Colonel" was his first name, not his title. Tooey placed monkeys on an island in the river as a sight for his visitors to see, but the primates soon swam to shore and established colonies of their own. Their descendants have lived there ever since.

Facing: The first detailed history of Silver Springs, concentrating on its pre-tourism days, was this booklet by Carita Doggett Corse. Originally published in the mid-1930s, it remained on sale with constantly evolving cover designs for decades. The tan-colored example on the left is probably one of the earliest printings; the green cover on the right is a 1947 edition.

Newton Perry was a local swimming teacher who devised various stunts to demonstrate the clarity of Silver Springs. He staged underwater scenes such as this one for photographer Bruce Mozert, and the images were distributed to magazines and newspapers nationwide. (We will hear more about Perry's exploits in future chapters.)

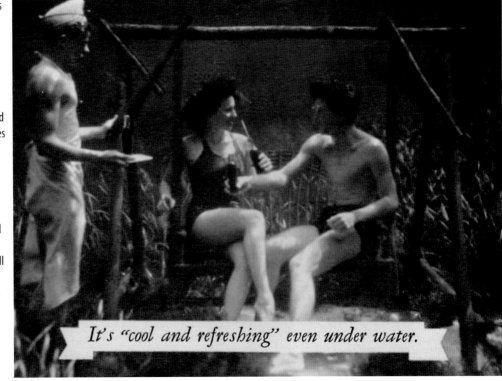

It's "cool and refreshing" even under water.

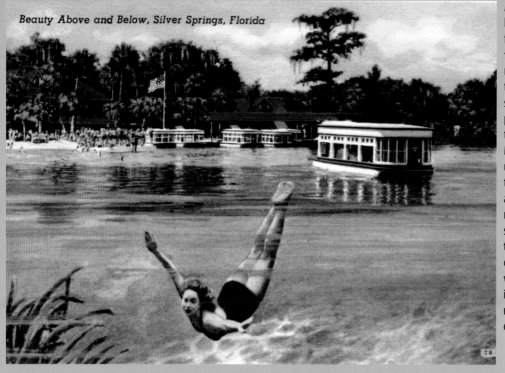

Beauty Above and Below, Silver Springs, Florida

Although this linen postcard from the late 1940s is obviously made up of two completely separate photos put together, it is typical of Bruce Mozert's talent for underwater photography. Florida attractions would not have been the same without featuring swimsuit-clad beautiful women, and this is only one of the many we shall be encountering.

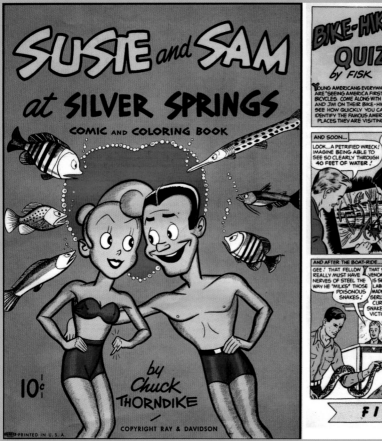

SUSIE and SAM
at SILVER SPRINGS
COMIC and COLORING BOOK

10¢

by Chuck THORNDIKE

COPYRIGHT RAY & DAVIDSON

PRINTED IN U.S.A.

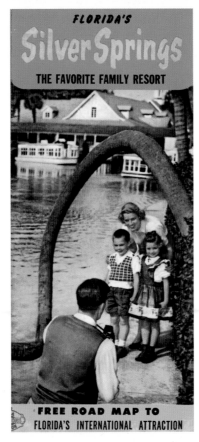

FLORIDA'S

Silver Springs

THE FAVORITE FAMILY RESORT

FREE ROAD MAP TO FLORIDA'S INTERNATIONAL ATTRACTION

By the early 1950s, Silver Springs' brochures were being printed in quantities of seven million at a time. The camera-toting "father" on the cover of this 1954 edition was Carl Ray's son Bill, who said, "I had the most famous back in the country."

Facing: This 1948 comic book described the pun-laden adventures of newlywed couple Susie and Sam as they sampled the many facets of Silver Springs. The back cover was a self-contained comic strip jointly advertising Silver Springs and Fisk bicycle tires.

Besides brochures, Silver Springs marketed itself in the scores of mom-and-pop motels that existed in Florida before the days of such chains as Holiday Inn and TraveLodge. Silver Springs photos could be found hanging on the walls of thousands of postwar motel rooms.

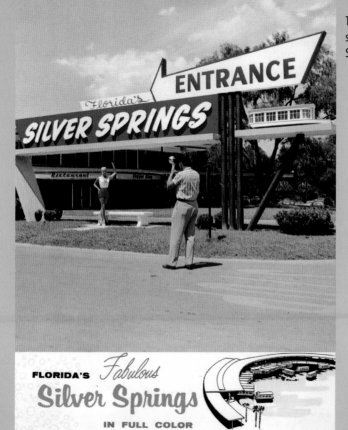

The cover of this 1958 souvenir booklet showed the Space Age design of the Silver Springs entrance sign.

By the 1950s, the promenade area next to the springs had developed into a collection of souvenir shops and snack bars. This glass was obviously designed to hold a healthy dose of that famous Florida orange juice.

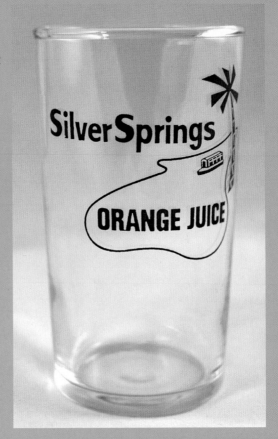

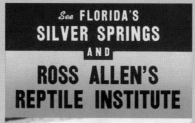

See FLORIDA'S
SILVER SPRINGS
AND
ROSS ALLEN'S
REPTILE INSTITUTE

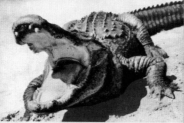

See Giant Alligators at the Reptile Institute

Daily Program

A tour consisting of lectures and demonstrations begins on the half hour, every hour until dark. One admission is good for all day, so you may come in and out as you please.

FLORIDA ATTRACTIONS ASSOCIATION

BRING YOUR CAMERA...

The first of several eventual ancillary Silver Springs attractions leased to various individuals was Ross Allen's Reptile Institute, dating to around 1930. Allen, a famed herpetologist, displayed his creepy crawlers for all to see. Regular demonstrations of "milking" rattlesnake venom for medicinal use were a regular part of the program.

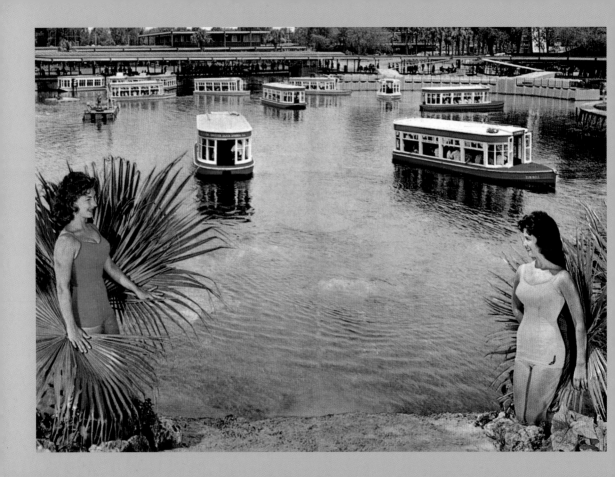

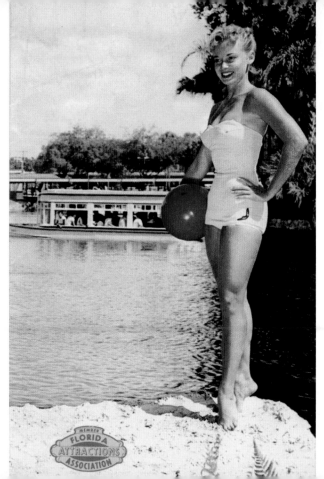

Geographically speaking, no spot in Florida is very far from a beach. Non-coastal attractions such as Silver Springs, however, often created their own beaches so tourists would not be tempted to venture elsewhere. And anywhere there was a Florida beach, one could find the ubiquitous bathing suit beauties who served as the unofficial trademarks of the Sunshine State.

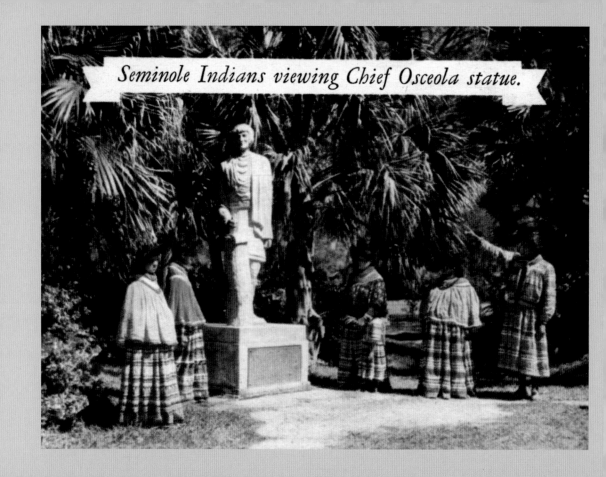

Seminole Indians viewing Chief Osceola statue.

In conjunction with the Reptile Institute, Ross Allen also operated a re-created Seminole village, complete with Native Americans demonstrating the crafts and customs of their ancestors. The idea of putting human beings on display as exhibits is a bit shocking today, but there were many other Florida attractions—especially in the Everglades' environs—that did essentially the same thing.

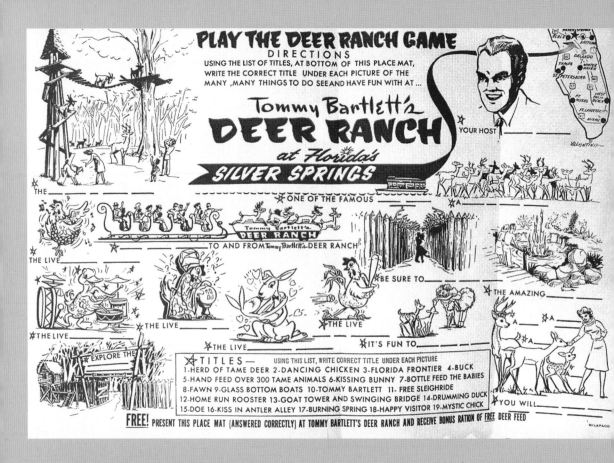

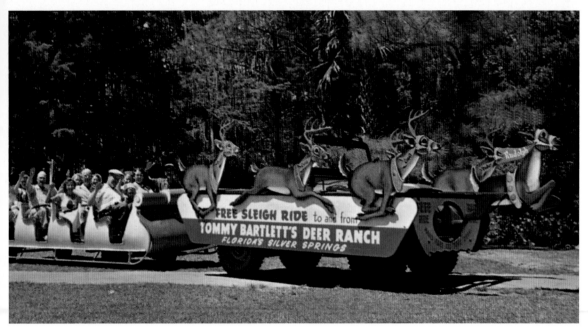

Facing: Wisconsin tourism mogul and TV personality Tommy Bartlett came to Silver Springs in 1954 with his Deer Ranch. This souvenir placemat was among the many pieces of promotional art created by commercial artist Val Valentine, who made his biggest mark on Florida tourism by developing attractions along the Miracle Strip of the Panhandle.

Val Valentine was also responsible for this rather unusual mode of transportation. Even during the hottest part of the summer, visitors rode this replica of Santa's sleigh and reindeer (complete with Rudolph's lighted red nose) to travel to the Tommy Bartlett Deer Ranch.

One of the attractions of Bartlett's mini-park was the opportunity to bottle-feed the constant supply of baby deer. Once the infants grew into adulthood, they were still perfectly willing to be fed by any tourist who happened to come along.

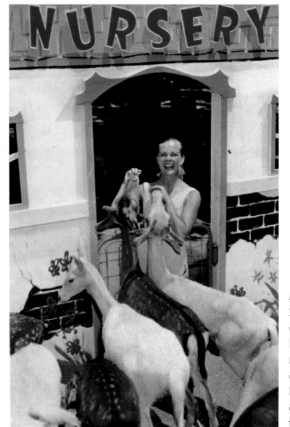

Facing: Another ancillary Silver Springs attraction of the mid-1950s was the Prince of Peace Memorial. A series of small chapels housed artist Paul Cunningham's wood carvings of scenes from the life of Christ.

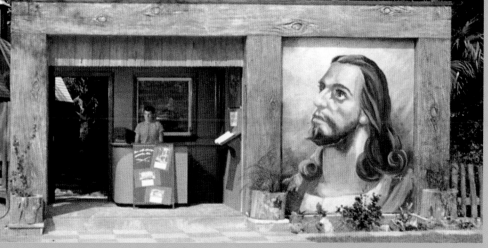

In 1962, after almost forty years of management by the Ray and Davidson partnership, Silver Springs was sold to the ABC television network. This brochure includes the logo ABC was using at the time to promote its color TV shows.

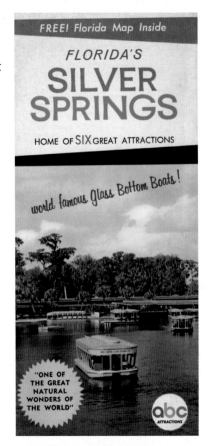

Facing: ABC certainly wasted no effort to promote its new tourism acquisition. This mid-1960s spread adeptly illustrates the many sights to be seen during a typical visit of that period.

Florida's SILVER SPRINGS

Explore the indescribable beauty of the world's largest group of crystal clear springs through the magic of world famous glass bottom boats. See more than 35 varieties of fish and 100 varieties of colorful plant life in 14 excitingly different spring groups. Admission to the 100 acre magnificently landscaped park and parking is all free.

Cafeteria on grounds — Food by Morrison's

The main spring basin glows like a huge jewel in the warm Florida sun.

Enjoy the splendor of the 100 acre landscaped park that borders the tranquil Silver River.

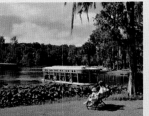

Walk eight feet under water. . . . Take never-to-be-forgotten pictures in air-conditioned aquatorium. . . . See spectacular specimens of plant and marine life through the sparkling crystal clear water.

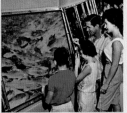

UNDERWATER MOTION PICTURE CAPITAL OF THE WORLD

Thrill to the untamed fury of huge alligators at the Ross Allen Reptile Institute.

A colony of wild "Tarzan" monkeys frolic in the dense tropical jungle along the Silver River and are thrown bits of food by the Captain of the Jungle Cruise.

CAMPING GROUND OF THE SEMINOLE INDIANS

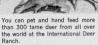

Rain or shine you can enjoy every attraction any day of the year.

Glass Bottom Boats operate continuously from 8:30 A.M. daily.

Marvel at thousands of fish and many varieties of beautiful plant life in fourteen sparkling springs through the magic of World Famous Glass Bottom Boats.

You can pet and hand feed more than 300 tame deer from all over the world at the International Deer Ranch.

The management might have changed, but other things stayed just the same. Combining the springs with glass bottom boats and pretty girls continued to be a winning formula for ABC.

Facing: Bruce Mozert was still churning out his famous underwater photos throughout the 1960s. The expression on model Betty Frazee's face seems to indicate that she is thinking, "Hurry up and take the picture, Mozert—I'm about to drown."

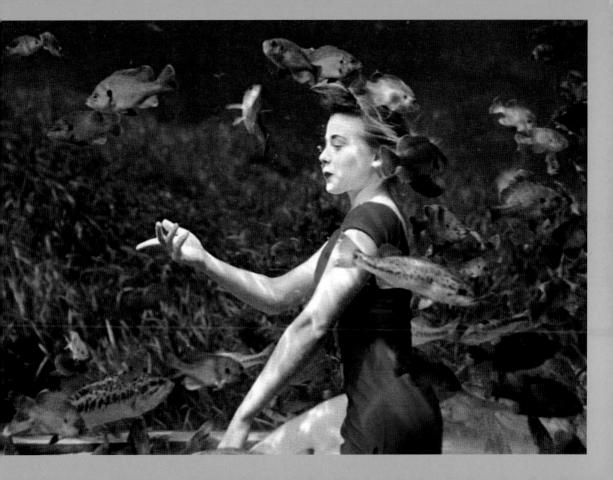

During the ABC ownership days, this impressive new entrance was constructed next to State Highway 40. And yes, that is your beloved author striking a hammy pose in front of it in 1970.

Facing: After being in storage for decades, the model glass bottom boat that formerly adorned the "rock pile" entrance fountain was located and restored as an exhibit in the park.

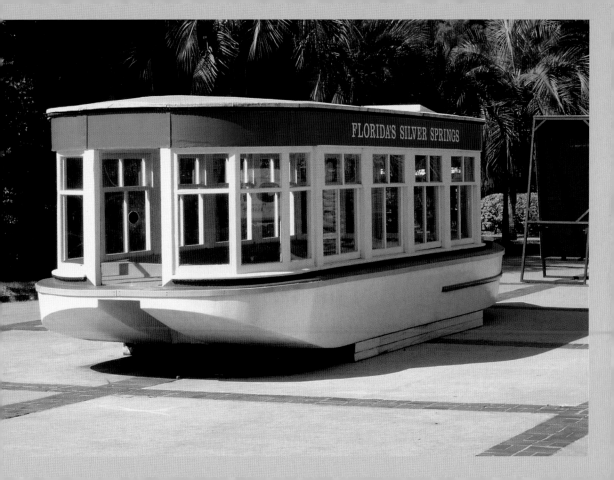

There was a craze for water parks in the tourism world during the 1980s, and Silver Springs' answer was Wild Waters. Located just west of the main entrance, it served as a splash zone for those antsy kids who were not content to glide over the springs' surface in a glass bottom boat.

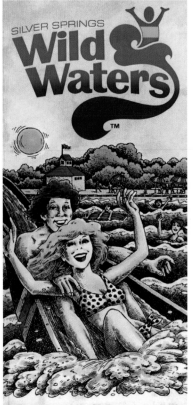

SILVER SPRINGS Wild Waters™

Are you wild enough?

Facing: A series of ownership changes resulted in more and more amusement park-type attractions being grafted onto Silver Springs, replacing such old standbys as the Reptile Institute and Deer Ranch. This 2006 brochure map shows just how congested things had become by that time.

SILVER SPRINGS®

Nature's Theme Park.

Silver Springs offers a variety of
refreshment choices. Seasonal
food concessions are conveniently
located throughout the park.

🍴 THE SPRINGSIDE CAFÉ

Relax in air-conditioned comfort and order from
a delicious menu of old-fashioned burgers, fries,
specialty sandwiches and entrée platters.

🍴 THE DELI

Freshly made sub sandwiches.

🍴 ICE CREAM & FUDGE SHOP

Ice cream treats made to order, with homemade
fudge and cookies baked fresh daily.

🍴 SPRINGS PIZZERIA

The taste of Italy comes to Silver Springs.

🍴 ROSS ALLEN ISLAND BAR

Frozen Daiquiris, Beer and Soft Drinks.

🍴 BILLY BOWLEGS CAFÉ

Tasty barbecue and specialty menu offered
during special events.

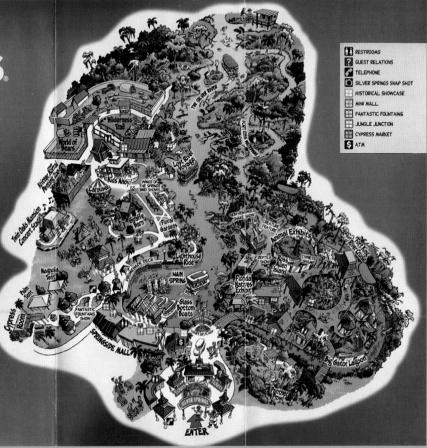

🚻	RESTROOMS
❓	GUEST RELATIONS
📞	TELEPHONE
📷	SILVER SPRINGS SNAP SHOT
	HISTORICAL SHOWCASE
	MINI MALL
	FANTASTIC FOUNTAINS
	JUNGLE JUNCTION
	CYPRESS MARKET
💲	ATM

In October 2013, Silver Springs left the world of commercial attractions to become a Florida State Park. Most of the rides and other commercial additions of the previous twenty years were removed, reverting the site to its natural beauty—which will never go out of style.

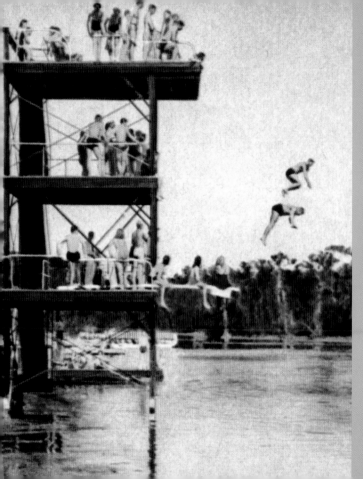

Wakulla Springs

Separated from the rest of Florida's attractions, Wakulla Springs might never have been noticed at all had it not been for its proximity to the state capital at Tallahassee. In 1934, the property was purchased by Edward Ball, brother-in-law of chemical tycoon Alfred Du Pont. As owner of the Florida East Coast Railroad, the Florida National Bank, and the St. Joe Paper Company, Ball had the funds to do pretty much as he pleased, and in 1935 he built a lodge at Wakulla Springs that was definitely intended for the upper class tourist trade.

It should be obvious that one important element of automobile tourism is a road on which to drive. This early Wakulla Springs brochure made much of the fact that there was finally a paved road leading from the state capital to the attraction.

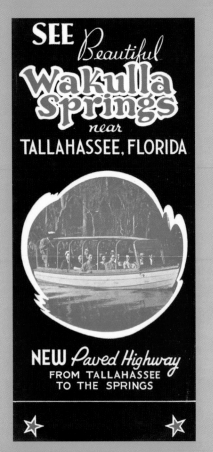

SEE *Beautiful*
Wakulla Springs
near
TALLAHASSEE, FLORIDA

NEW *Paved Highway*
FROM TALLAHASSEE
TO THE SPRINGS

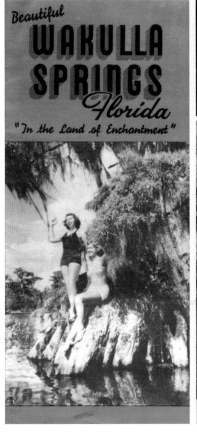

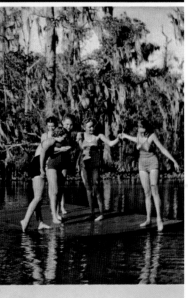

One would think a staid, conservative park such as Wakulla Springs would not need to resort to pretty girls in bathing suits for its advertising. One would be wrong.

Although it was in no way a competitor to Silver Springs, Wakulla Springs had its own fleet of glass bottom boats and a "jungle cruise" as well. The way these Wakulla tourists are dressed might be a good indication of the different class of visitors the attraction brought in.

Wakulla Springs Lodge, Fifteen Miles South of Tallahassee, Wakulla Springs, Florida

Enjoying Underwater Scenes from Glass Bottom Boat

The most promoted sight of Wakulla's jungle cruise was Henry, the Pole-Vaulting Fish. In reality, the piscatorial performer simply swam over his submerged pole, but the fact that he seemingly did it on cue was enough to make him a star.

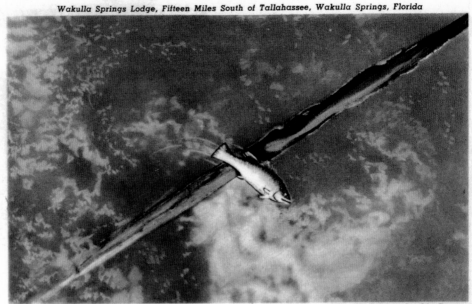

Wakulla Springs Lodge, Fifteen Miles South of Tallahassee, Wakulla Springs, Florida

"Henry," the Pole Vaulting Fish—A Veteran Performer for Sight-Seers and World Famous for his Capers

Facing: This view of the interior of Edward Ball's Wakulla Springs Lodge is a good indicator that this resort was intended for the economic upper end of the tourist crowd.

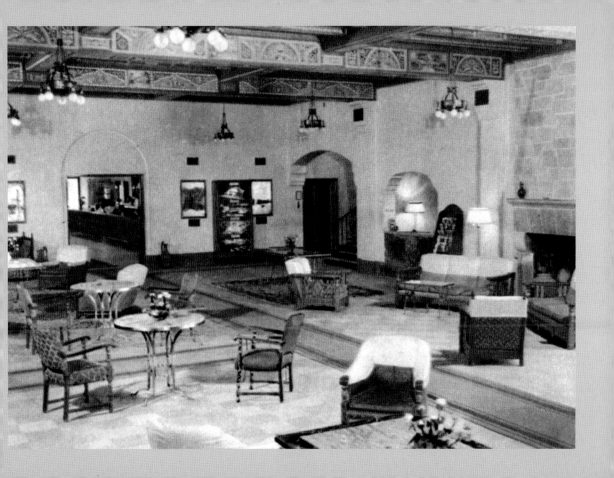

Although Wakulla Springs never attracted the sheer number of tourists enjoyed by Silver Springs and the others, it still promoted itself as a "sight-seers paradise." This view shows the signboard listing at least eight different sights for those seers to sight-see . . . See?

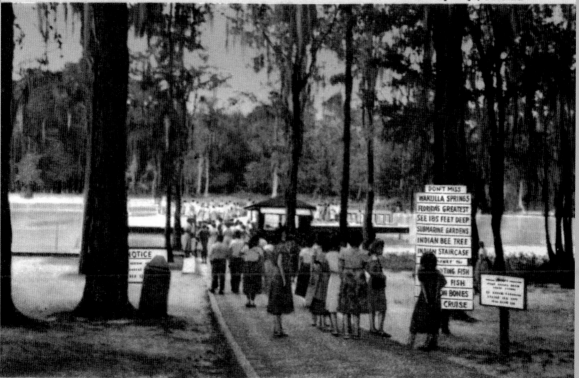

Wakulla Springs Lodge, Fifteen Miles South of Tallahassee, Wakulla Springs, Florida

Sight-Seers Paradise

This triple-level diving platform looks a bit dangerous; but, considering that this photo dates from the World War II era, these young people probably felt the rest of the world was hazardous enough that they had nothing to lose.

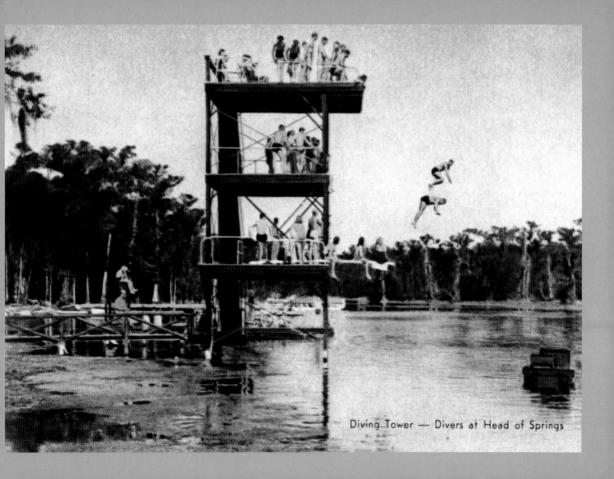

Diving Tower — Divers at Head of Springs

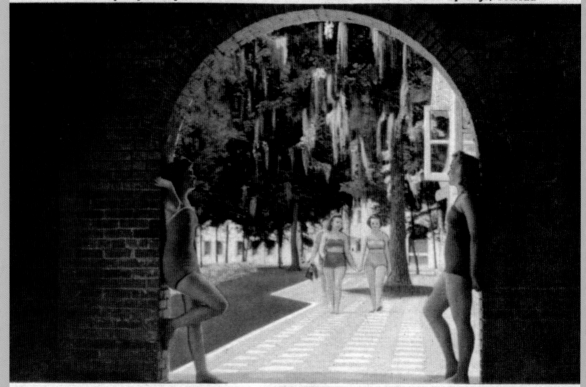

Looking toward Lodge from Bathhouse

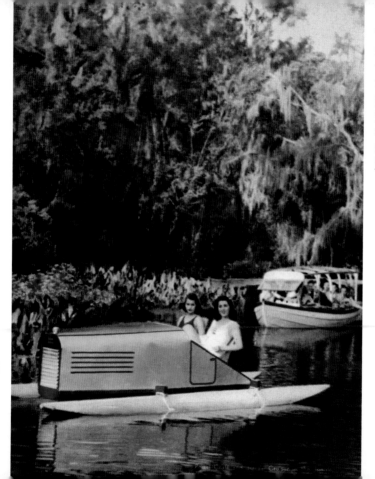

The river at Wakulla Springs was home to a varied assortment of water traffic, from leg-powered paddleboats to these spiffy yellow-and-red pontoon models to the ever-present glass bottom boats and jungle cruise crafts.

Facing: Swimsuits, and the poses to display them properly, abound in this view looking toward Wakulla Springs Lodge from its bathhouse.

This account of Wakulla Springs' history was published during World War II. It mentions that many of the Springs' female employees were wearing the insignias of their boyfriends' branches of the military.

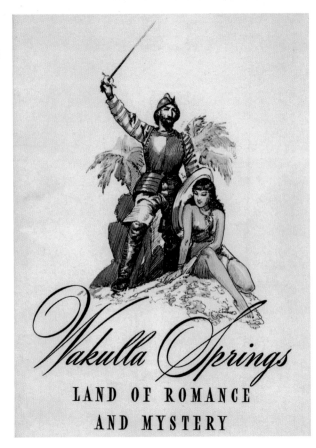

Facing: In the early 1940s, Newt Perry migrated from Silver Springs to Wakulla Springs, and continued to up his game of staging underwater scenes for the benefit of photographers. As we shall see a few pages hence, this idea would reach its full potential in the postwar years.

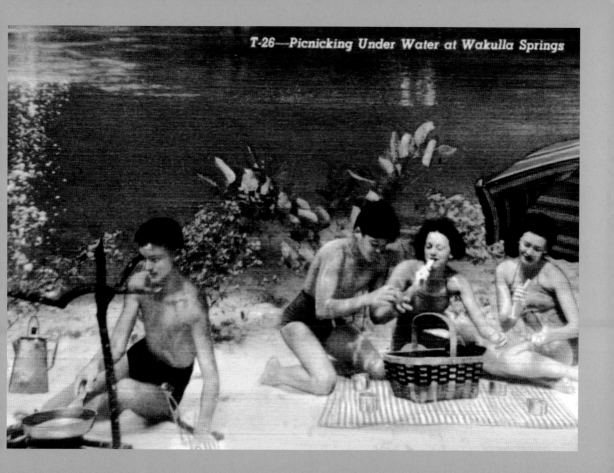

T-26—Picnicking Under Water at Wakulla Springs

When it came to the pretty girls department, Wakulla Springs was fortunate enough to be a practice court for the Florida State College for Women's synchronized swimming team, the Tarpon Club. The all-female college went co-ed in the late 1940s and is now Florida State University.

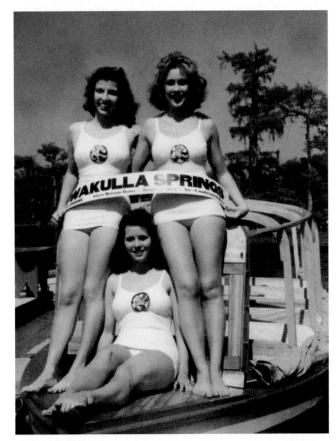

Facing: Even the presence of the Tarpon Club ladies was not enough to sustain Wakulla Springs as a commercial attraction. After Edward Ball died in 1981, Florida acquired Wakulla as a state park in 1986.

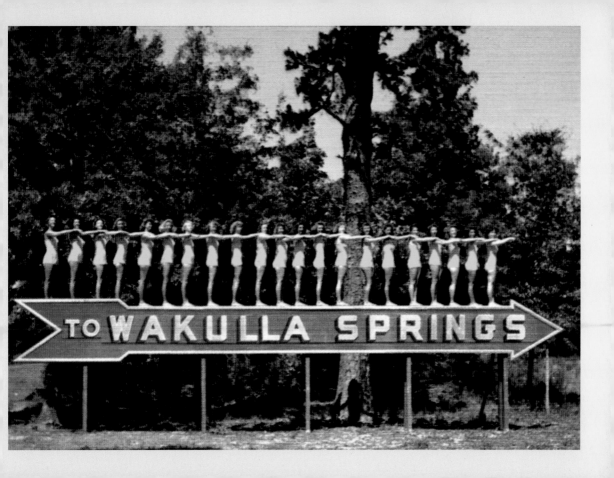

3

Rainbow Springs

A short distance west of Silver Springs, near the town of Dunnellon, was another beautiful natural spot with the tranquil name of Blue Springs. When businessmen Frank Greene and F. E. Hemphill teamed up in 1937 to develop this property into a new tourist attraction, one of their first steps was to add red, orange, yellow, green, indigo, and violet to the existing blue and rename it Rainbow Springs. (This was ostensibly because of the prism-like reflections visible below the water's surface.) Under its new name, Rainbow Springs soon became a colorful part of Florida's roadside landscape.

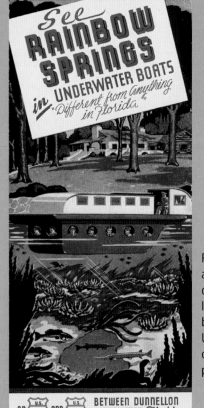

Rainbow Springs opened as an attraction in 1937. It had the distinct advantage of being located on one of the state's busiest north–south highways, U.S. 41, ensuring that millions of automobile tourists would pass its entrance annually.

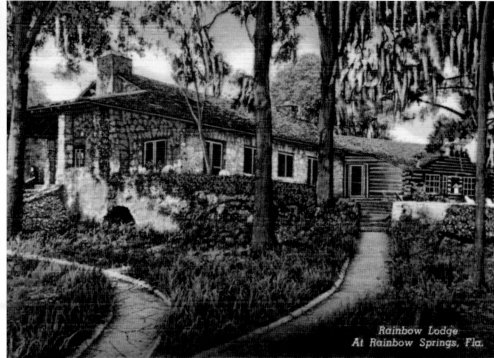

Rainbow Lodge
At Rainbow Springs, Fla.

The Rainbow Lodge was promoted on a 1950s phonograph record by a mouthwatering rhyme: "Up there, they're serving golden fried chicken and candied yams, and specialize in Virginia baked ham. If you make up your mind to take time and dine, our lodge is recommended by Duncan Hines."

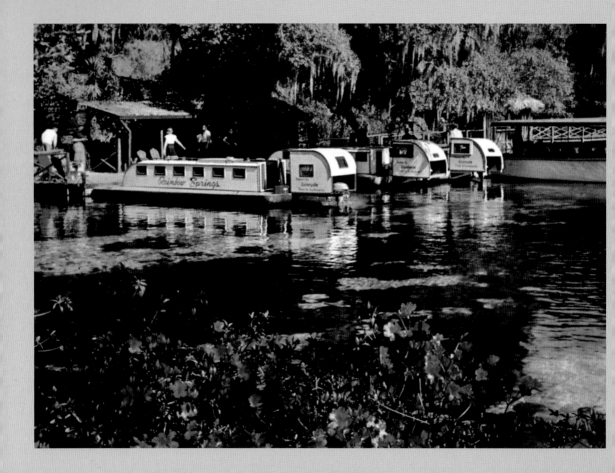

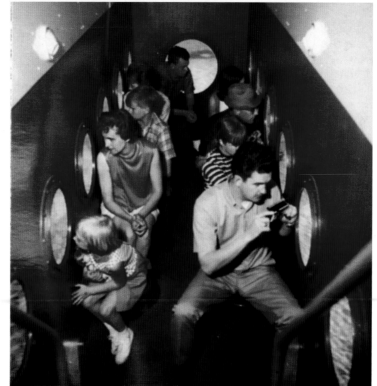

Submarine Boat passengers viewed Rainbow Springs' underwater world through portholes in the submerged lower half of each vessel.

Facing: Although Rainbow Springs did have a fleet of glass bottom boats, its more distinguishing watercrafts were its Submarine Boats. As their name implied, these vessels seated their passengers underwater instead of having them peer down through the bottom of the boat.

Naturally enough, Rainbow Springs employed the rainbow motif in virtually all of its brochures through the years. It is probably no coincidence that the brochure illustration with the diving woman strongly resembles one of the Silver Springs postcards we saw several pages ago.

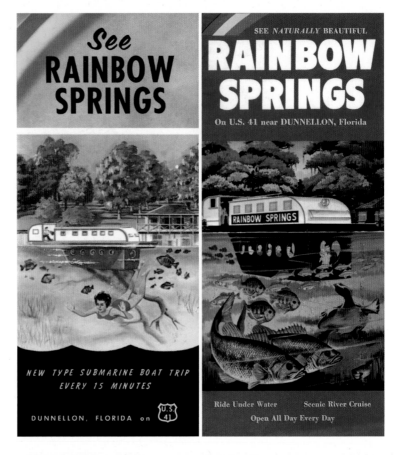

See RAINBOW SPRINGS

NEW TYPE SUBMARINE BOAT TRIP EVERY 15 MINUTES

DUNNELLON, FLORIDA on U.S. 41

SEE *NATURALLY* BEAUTIFUL RAINBOW SPRINGS

On U.S. 41 near DUNNELLON, Florida

Ride Under Water Scenic River Cruise

Open All Day Every Day

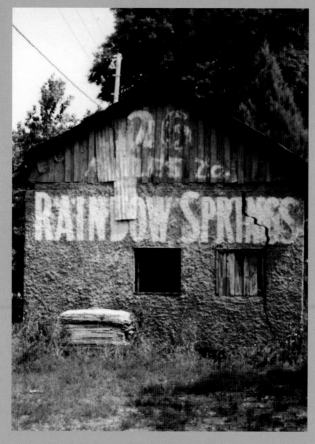

For several years, Rainbow Springs was leased to the operators of Lookout Mountain's famed Rock City Gardens. During that period, the "See Rock City" barn painters were dispatched into Florida to create similar roadside ads for the company's other attraction.

Although souvenirs from Rainbow Springs are not nearly as plentiful as those from its more famous tourism cousins, occasionally artifacts such as this drinking glass will show up. The Submarine Boats were still the main attraction.

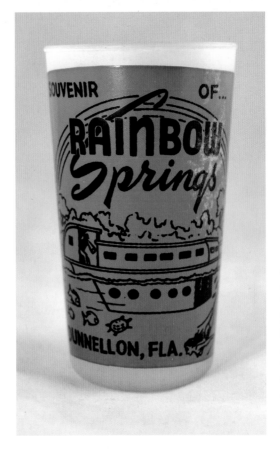

Facing: This impressive comic strip–style spread from one of Rainbow Springs' 1950s brochures highlighted some of the attractions available at the time. Notice that the final panel did not hesitate to point out its prime location along heavily traveled U.S. 41.

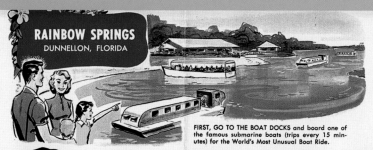

RAINBOW SPRINGS
DUNNELLON, FLORIDA

FIRST, GO TO THE BOAT DOCKS and board one of the famous submarine boats (trips every 15 minutes) for the World's Most Unusual Boat Ride.

THROUGH INDIVIDUAL PORTHOLES you'll watch the unfolding of an underwater fairyland as the guide chants the story of this amazing wonder of Nature.

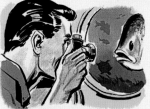

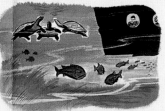

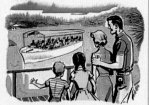

FISHY STARES will greet you as you ride dry and comfortable five feet below the surface of the water.

YOU WILL STEP INTO ANOTHER WORLD— mysterious and silent, inhabited by a myriad of strange and colorful marine life.

UNDERWATER FOLIAGE reflects sunlight in rainbow hues.

AMONG OTHER THINGS for the family to enjoy is the 5-mile cruise down Rainbow River in a glass-bottom boat.

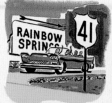

ENCHANTING Jungle Trail winds around mossy oaks and tropical flowers bordering Rainbow Springs.

YOU'LL SEE the highest waterfall in Florida—another perfect picture setting.

CRYSTAL WATERS of Rainbow Springs are 74° all year. Restaurant offers delicious food. Gift Shop features photo supplies as well as souvenir items.

YOU'LL COME BACK again to Florida's naturally beautiful attraction.

In the late 1960s and early 1970s, Rainbow Springs was owned by an unusual joint partnership of S&H Green Stamps and Holiday Inn. Many features were added to bring the rather bucolic attraction into the modern tourism world, including this eye-catching fountain alongside U.S. 41.

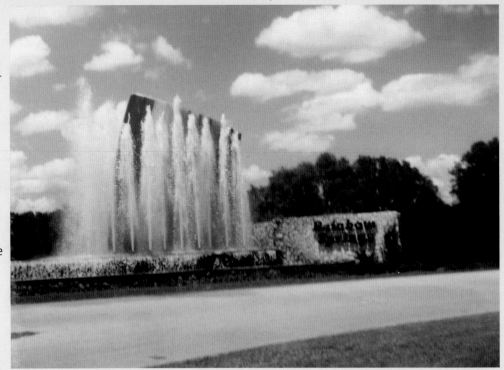

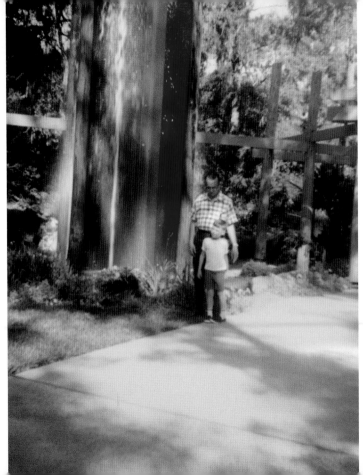

The rainbow theme became ever more prominent during the Green Stamps/Holiday Inn period. This smaller fountain appeared just inside the gates—and yes, that is young author Hollis along with his pappy in 1969.

It will restore your faith in Fairy Tales

Dunnellon, Florida

Thanks to corporate thinking, Rainbow Springs at last had a consistent logo to use in all of its advertising. Besides a new round of brochures, framed montages of Rainbow Springs scenes appeared in motel lobbies and restaurants throughout the area.

Rainbow Springs

U.S. 41 at Dunnellon, Florida, west of I-75

One of the most fondly remembered additions of the Green Stamps/ Holiday Inn days was the Forest Flite monorail ride. In cars shaped like giant leaves, guests were whisked through the jungle to enjoy the various sights.

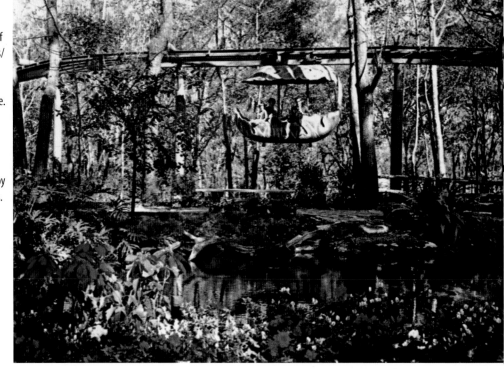

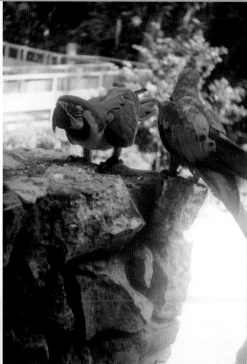

At one point, the Forest Flite ride passed through an aviary full of colorful tropical birds. Even outside that enclosure, parrots and macaws could be found stationed throughout the park to delight visitors.

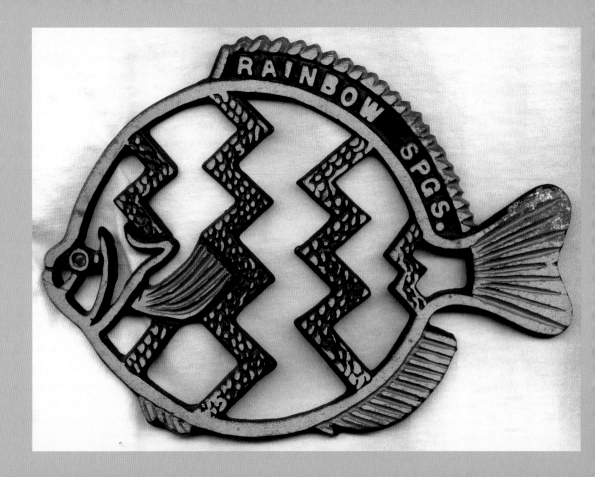

Among the many later-era souvenirs from Rainbow Springs was this fish-shaped trivet, on which the attraction's name looks more like an afterthought than anything else. Felt pennants were a standard item in any souvenir shop, and this one used imagery of not only the new logo but also the monorail and the entrance fountain.

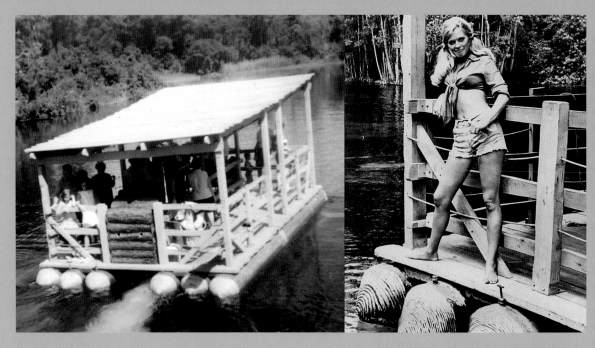

The Rainbow Rafts plied the river during the early 1970s and occasionally picked up interesting passengers for publicity purposes. No, in case you're wondering, that isn't Daisy Duke.

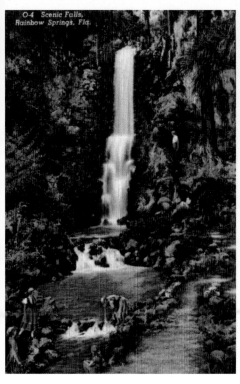

O-4 Scenic Falls,
Rainbow Springs, Fla.

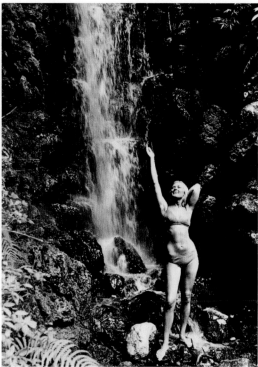

Rainbow Springs made no secret of the fact that its scenic waterfall was completely man-made and circulated water pumped in from the river. These two shots from the late 1930s and early 1970s show that while the waterfall remained consistent, the way it was marketed changed quite a bit.

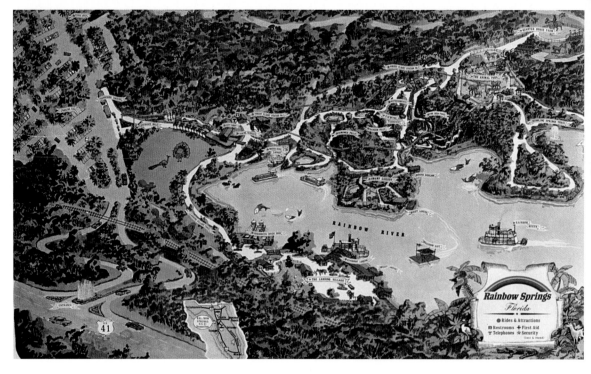

By the time of this poster-sized souvenir map, Rainbow Springs was walking an unsteady line between being a natural attraction and a mini theme park. Either way, U.S. 41 traffic had been routed miles away to I-75, and the attraction closed in March 1974.

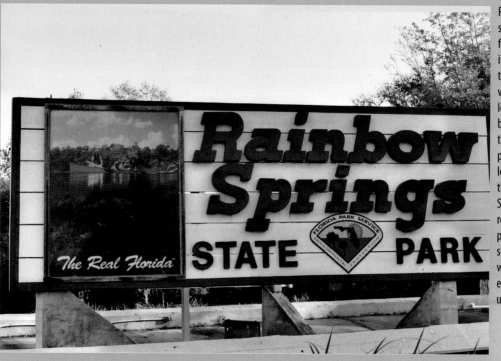

Rainbow Springs sat abandoned for ten years after its closing, but in the early 1980s, volunteers from local garden clubs began doing what they could to preserve what was left. In March 1995, the new Rainbow Springs State Park reopened to the public, with this signage mounted where the entrance fountain used to be.

In 2005, one of the original Submarine Boats still sat aground in the state park, awaiting a possible restoration project that would let visitors view underwater scenery via video screens mounted in the former portholes.

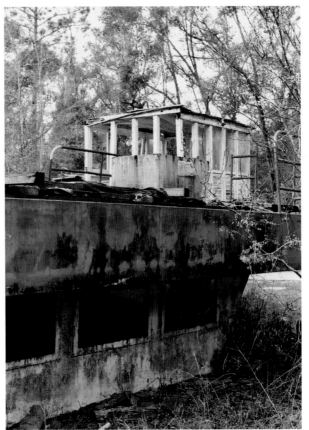

Facing: Even with such attractions as the monorail, aviary, and leggy models removed, Rainbow Springs State Park has preserved the natural beauty of this Florida spot.

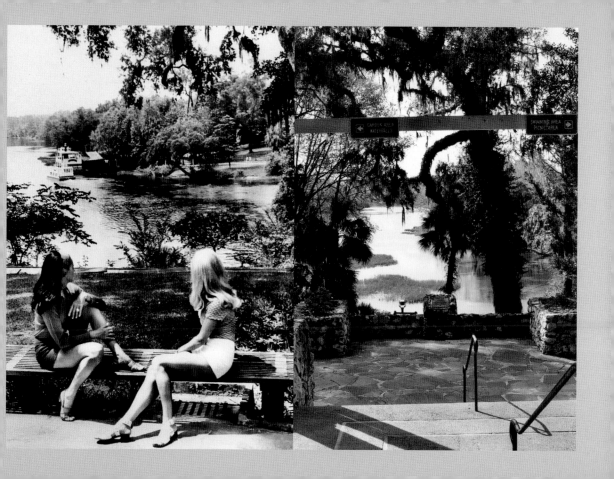

4

Weeki Wachee Spring

In our previous chapters, we have seen how swimming champion Newt Perry worked with both Silver Springs and Wakulla Springs to perfect his creative concepts of underwater performance. In 1947, Perry and business partner Hall Smith opened their own attraction at a spot with the tongue-twisting name of Weekiwachee Spring. Perry, a born showman, used all the experience with publicity gimmicks he had gained up to that point, making the focal attraction an underwater show visitors would watch from a submerged theater. At first, the idea of building his attraction around a mermaid theme seems to have escaped Perry's imagination, but not for long—and thereby hangs a tail.

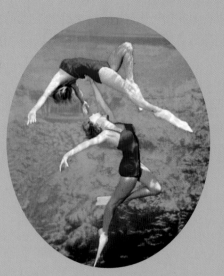

Facing: Originally, "Weekiwachee" was spelled as a single word, and the attraction built around its spring had nothing to do with mermaids. The selling point was watching both male and female swimmers enacting ballet poses against the backdrop of the spring's "underwater mountain."

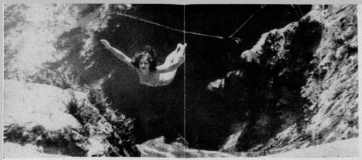

World's Champion Swimmers Perform at the

MOUNTAIN UNDERWATER

Already selected by major motion picture companies as The Underwater Capital of the World!

At left: Swimming all the year-round in water always 74 degrees. Bath house and bathing beach. Center: Entrance to gift shop, main offices and theatre.

WEEKIWACHEE SPRING is directly on U.S. 19, 12 miles West of Brooksville. Easily reached from any point in Florida.

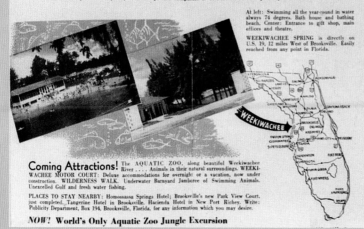

Coming Attractions!
The AQUATIC ZOO, along beautiful Weekiwachee River Animals in their natural surroundings. WEEKI-WACHEE MOTOR COURT: Deluxe accommodations for overnight or a vacation, now under construction. WILDERNESS WALK. Underwater Barnyard Jamboree of Swimming Animals. Unexcelled Gulf and fresh water fishing.

PLACES TO STAY NEARBY: Homosassa Springs Hotel; Brooksville's new Park View Court, just completed. Tangerine Hotel in Brooksville. Hacienda Hotel in New Port Richey. Write: Publicity Department, Box 194, Brooksville, Florida, for any information which you may desire.

NOW! World's Only Aquatic Zoo Jungle Excursion

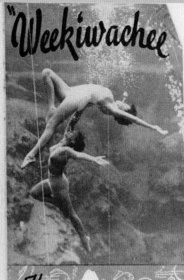

"Weekiwachee

The MOUNTAIN UNDERWATER!

On the Main Gulf Coast Highway
U.S. 19

A NEWLY DISCOVERED PHENOMENON IN THIS WORLD!!

There Is Nothing Else Like It!

All of Newt Perry's experience in staging underwater scenes came in handy at his new Weeki Wachee Spring attraction. An entire theater was built to place visitors underwater, where they watched the show unfold against the spring's alien-looking landscape.

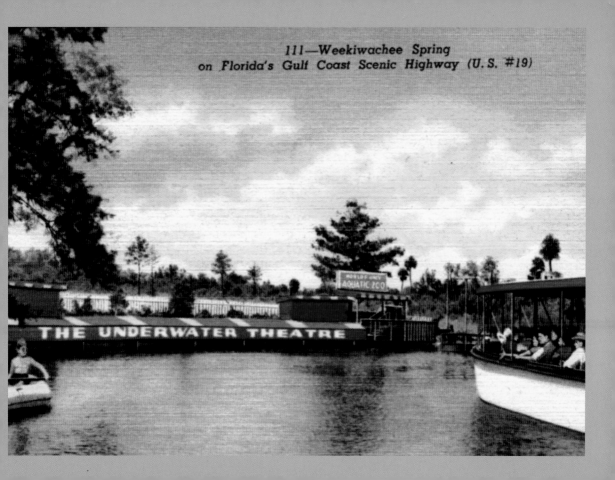

111—Weekiwachee Spring
on Florida's Gulf Coast Scenic Highway (U.S. #19)

THE UNDERWATER THEATRE

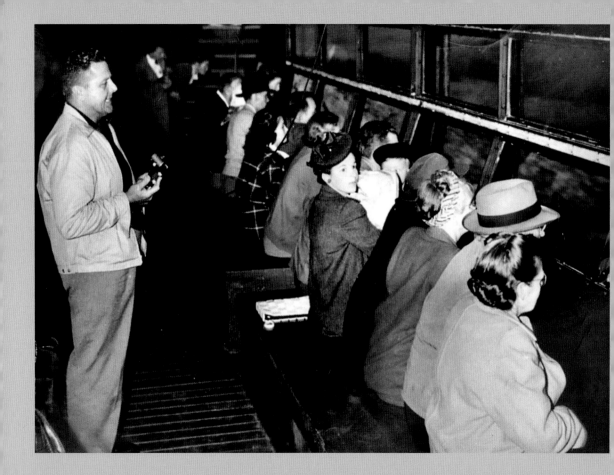

In Weeki Wachee's first underwater theater, there obviously was not a lot of seating. Guests pressed their faces against the glass windows to watch the performance, while Newt Perry provided a running commentary.

After Weeki
Wachee was used
as a location for
the filming of
*Mr. Peabody and
the Mermaid*
(1948), mermaid
iconography
began showing
up more and
more regularly in
the signage and
advertising.

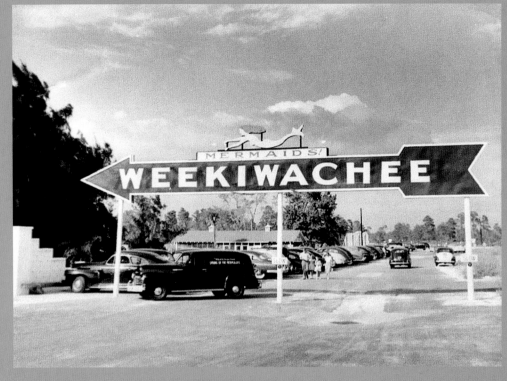

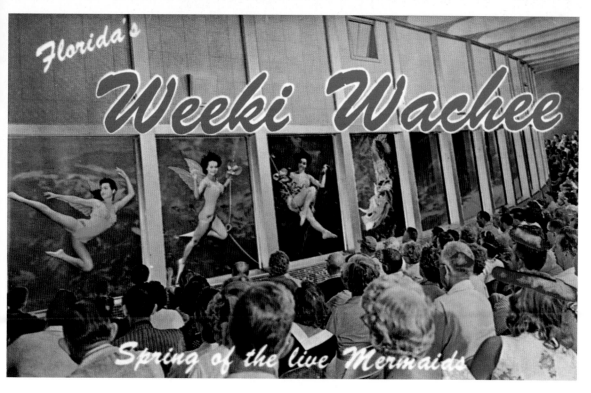

Florida's *Weeki Wachee*

Spring of the live Mermaids

Approximately ten years after its opening, Weeki Wachee replaced the original underwater theater with this giant auditorium-like building. The seating and acoustics were much improved, and the theater now had huge plate glass windows for showcasing the ever-more-elaborate shows.

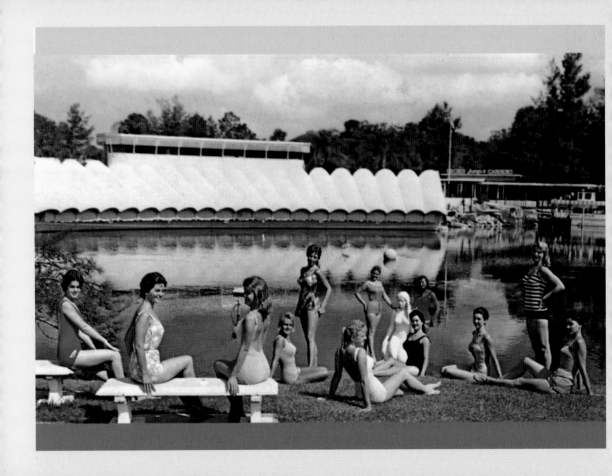

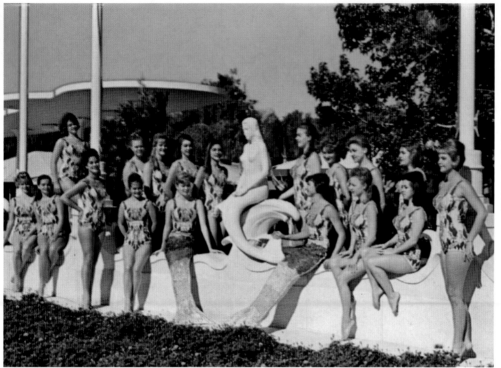

If other Florida attractions relied heavily on beautiful women for their appeal, Weeki Wachee certainly outdid the rest. Its staff of performers was referred to as "the world's most unusual career girls."

So as to ward off any possible infractions by amorous dads 'n' grads, Weeki Wachee's performers were housed in the sorority house—like Mermaid Village. The dorms had strict den mothers to be sure no rules of propriety were violated.

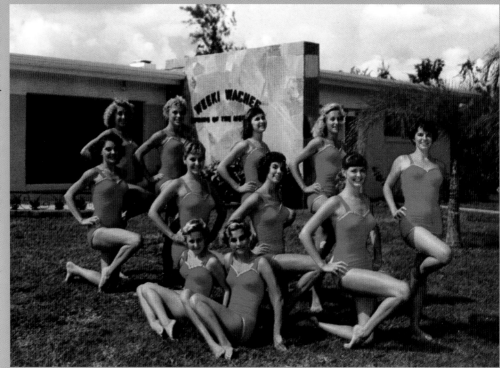

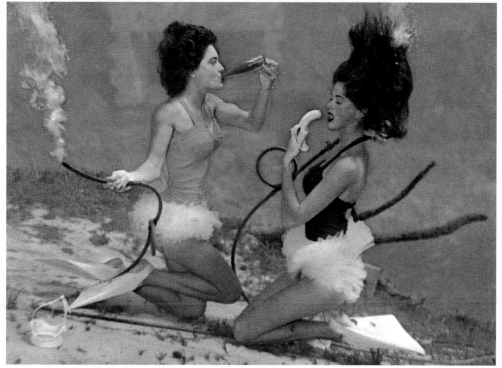

Considering the athletic ability required to be a Weeki Wachee performer, at least some of them could possibly have fought off any unwanted suitors with their bare fists. As an example, take an admiring look at the biceps on the mermaid on the left, which would not have been out of place on an Olympic gold medalist.

Speaking of strength and conditioning, Weeki Wachee's trademark from the earliest days was the adagio, in which one mermaid effortlessly lifted another over her head. As healthy as the athletes were, obviously this stunt required less muscle when performed in the weightless underwater world.

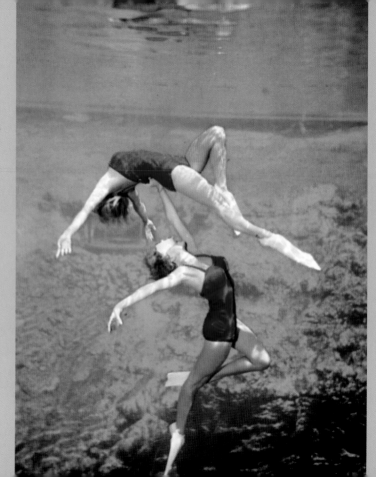

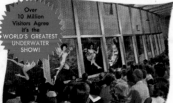

After ABC bought Weeki Wachee in 1959, the promotional literature began featuring endorsements from a wide variety of celebrities, including Bob Hope, Arthur Godfrey, and Roy Rogers.

Once ABC acquired Silver Springs in 1962, much cross promotion ensued. For example, this orange-shaped juice cup is imprinted with the Silver Springs name on one side and Weeki Wachee's on the other, so it could be sold at either park.

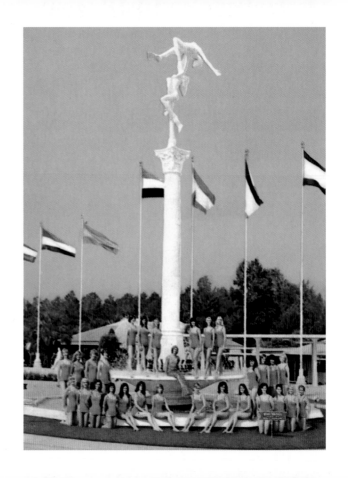

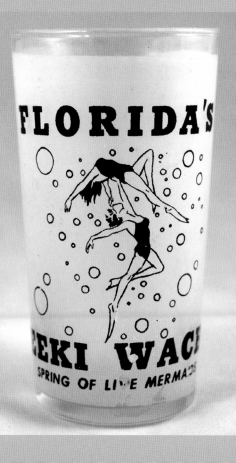

Effortless or not, the adagio pose appeared everywhere at Weeki Wachee, from the statue that graced the entrance fountain to innumerable souvenirs, including this glass. After the attraction was purchased by the ABC television network in 1959, such advertising became even slicker.

While not watching the mermaid show, Weeki Wachee guests could take a cruise down the river on the *Congo Belle*, a sidewheel riverboat with a glass bottom.

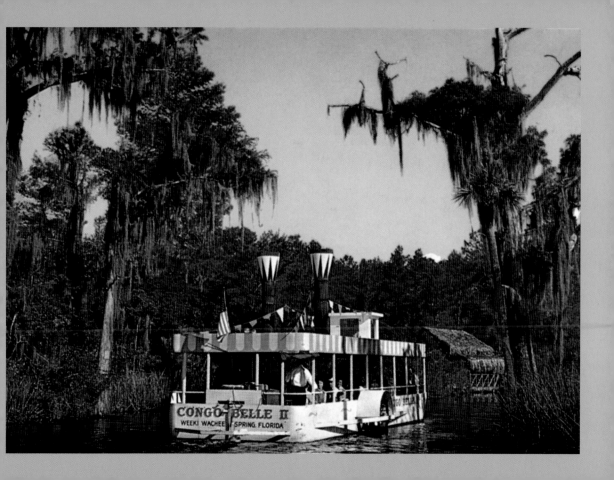

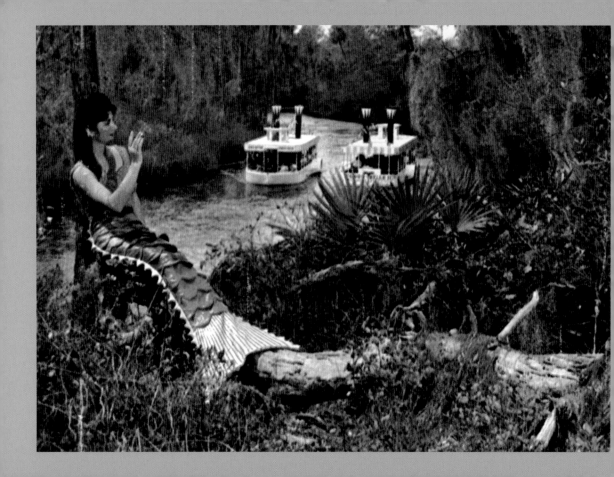

Even when promoting the riverboat ride, mermaids were not far from the advertising department's mind.

Weeki Wachee's Wilderness Chief Wagon Train traveled the back roads around the spring, making a stop at an "abandoned Seminole village"—which at least saved the attraction the expense of having to hire employees to portray the residents.

After ABC took control, the underwater shows became far more elaborate than Newt Perry's ballet poses. Entire scripted productions were fashioned from beloved stories, all given a liquefied twist.

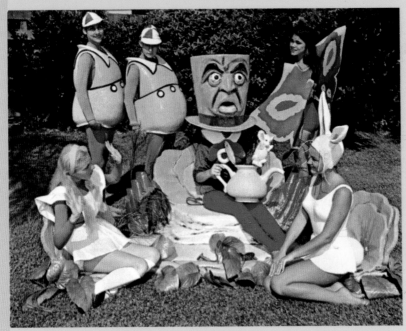

WEEKI WACHEE

Presents

"ALICE IN WATER-LAND"

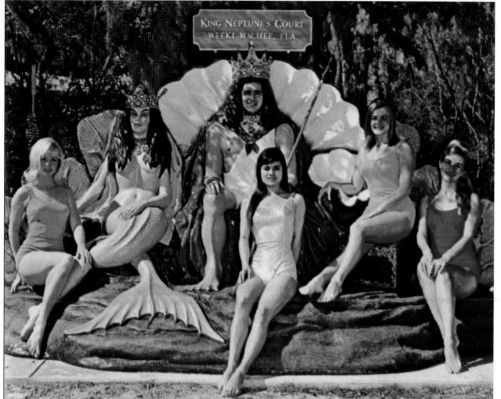

One addition of the 1960s was the Star Garden, with large fiberglass props to serve as photo ops for visitors. Here, a selection of the mermaids surround the recreation of King Neptune and his court.

Adolph the Porpoise and Bubbles the Seahorse had formerly been featured, respectively, in the 1964 and 1965 mermaid shows before their retirement in the Star Garden.

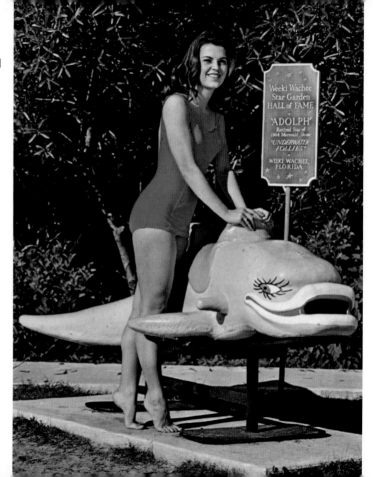

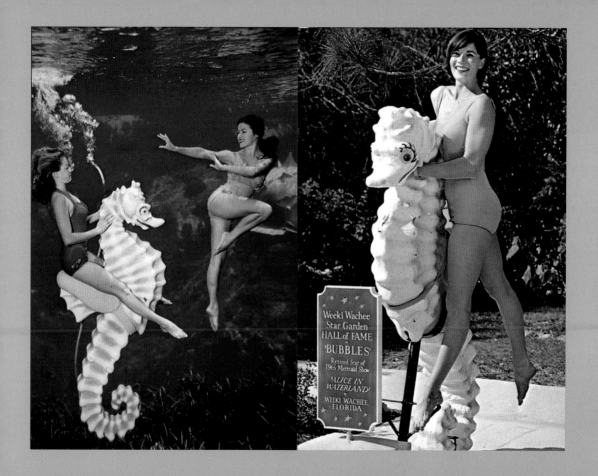

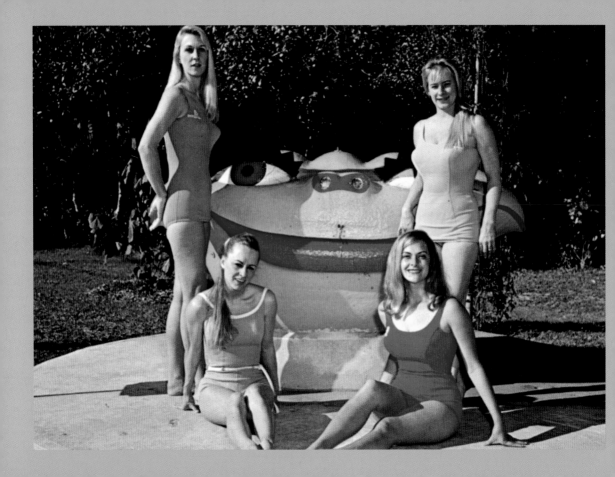

There was no escaping the American Bicentennial in 1976, and Weeki Wachee naturally came up with its own eye-catching way to contribute to the patriotic fervor.

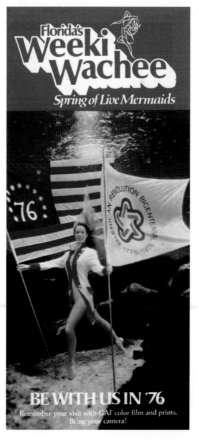

Facing: Many of the Star Garden props were "retired" stars from past underwater shows. This was—are you ready for this one?—"Clamity Jane."

In November 2008, Weeki Wachee Spring became the latest attraction to leave the commercial world and become a Florida State Park. Its history and reputation were so inextricably linked to the mermaid image, though, that the underwater shows continue today in much the same format as the last forty years or more.

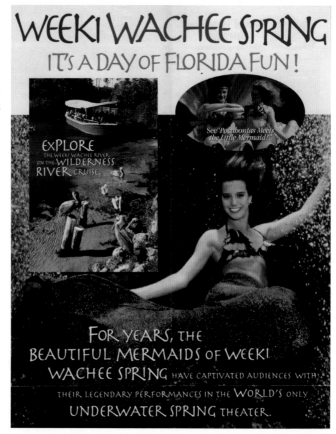

WEEKI WACHEE SPRING
IT'S A DAY OF FLORIDA FUN!

EXPLORE THE WEEKI WACHEE RIVER ON THE WILDERNESS RIVER CRUISE.

See "Pocahontas Meets the Little Mermaid!"

FOR YEARS, THE BEAUTIFUL MERMAIDS OF WEEKI WACHEE SPRING HAVE CAPTIVATED AUDIENCES WITH THEIR LEGENDARY PERFORMANCES IN THE WORLD'S ONLY UNDERWATER SPRING THEATER.

Homosassa Springs

David Newell, an avid fisherman of some renown, was first attracted to the waters of Homosassa Springs in 1940 because of an unusual phenomenon. For reasons unfathomable, this particular spring featured numerous varieties of both saltwater and freshwater fish intermingled with each other. Sensing an angler's angle he could promote, Newell opened a park he called Nature's Giant Fish Bowl, with its location at Homosassa Springs relegated to almost a footnote. It would be left to future developers to deep-six the unwieldy Fish Bowl name and give the attraction a moniker that made it the latest in the great Florida tourist springs race.

For its first two decades as an attraction, Homosassa Springs was known as "Nature's Giant Fish Bowl." An underwater walkway enabled visitors to get an up close and personal view of the spring's diverse mixture of fish.

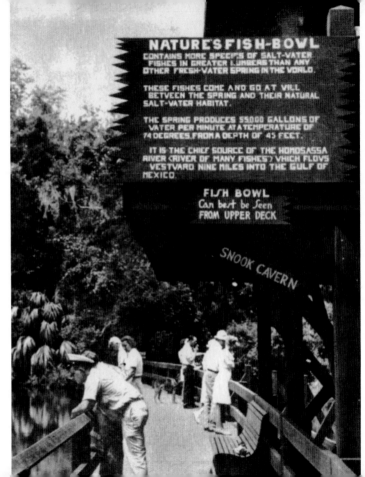

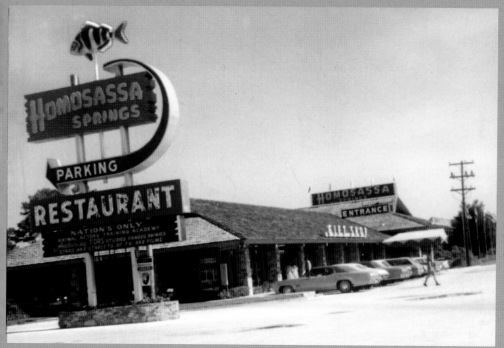

In 1962, Homosassa Springs was purchased by developer Bruce Norris, who set out to bring it in line with the other commercial springs attractions. This new entrance complex and neon sign, complete with rotating fiberglass fish, drew visitors off busy U.S. 19.

The Norris Development ownership brought many new features to Homosassa, including the Springs Restaurant and this fountain that was especially beautiful at night.

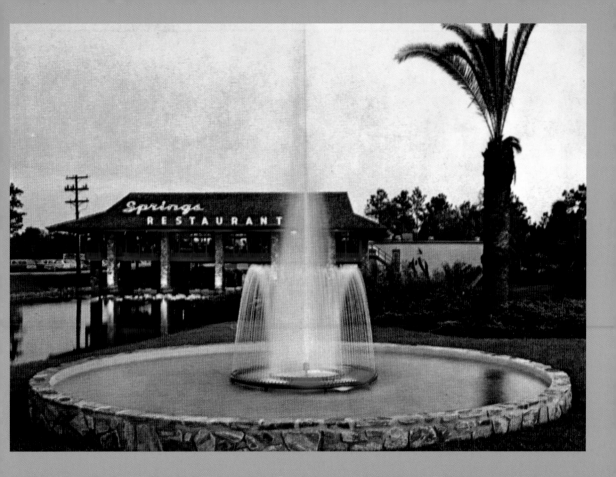

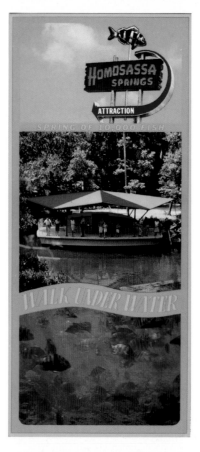

Recognizing its long-standing selling point, the "new" Homosassa Springs continued to emphasize the underwater observatory, an updated version of the attraction's original feature.

HOMOSASSA
SPRINGS
FLORIDA

"Nature's Own Attraction"

The new floating observatory built by Norris Development was considerably more spacious than the one David Newell had constructed in 1940, but the fish remained the same even as their human watchers progressed through the decades.

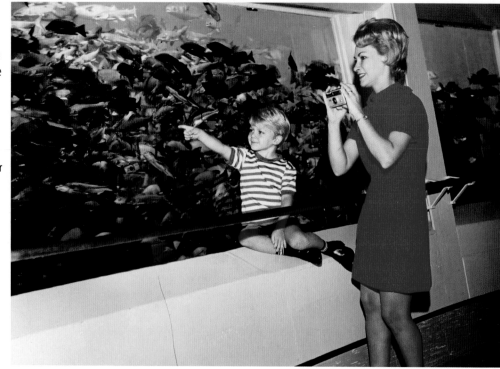

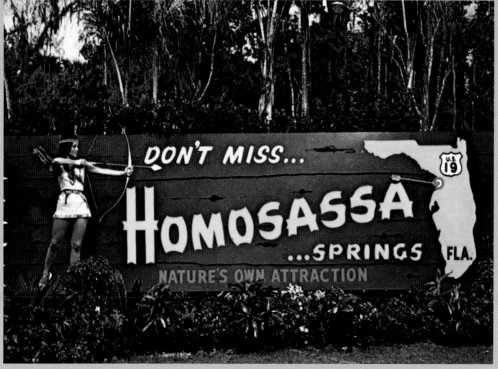

DON'T MISS...
HOMOSASSA
...SPRINGS
NATURE'S OWN ATTRACTION

U.S. 19

FLA.

Homosassa Springs' roadside billboards featured the image of a mini-skirted Native American princess. For this postcard, one of the attraction's live models filled in as the logo.

This incredible artwork was originally created as a placemat for use in the Springs Restaurant; it later appeared on postcards and in brochures. The artist was Val Valentine, whom we heard about back in the Silver Springs chapter. By this time, he was becoming one of the tourism impresarios of the Florida Panhandle's Miracle Strip.

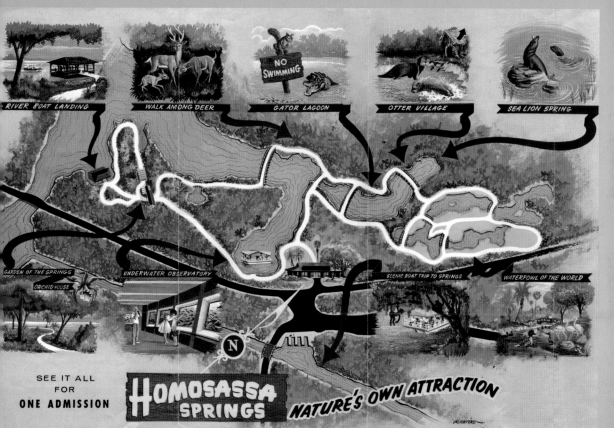

The Crows Nest

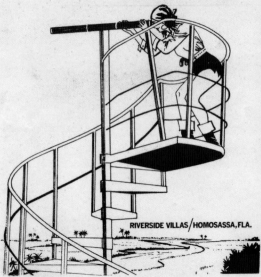

RIVERSIDE VILLAS / HOMOSASSA, FLA.

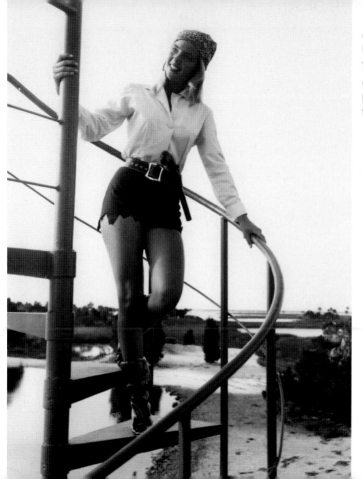

Another import from the Miracle Strip was model Melody May, who could usually be found posing on the beach for bikini shots. At Homosassa, she donned a fetching pirate outfit, and was captured in artwork for the Crow's Nest Restaurant menu cover.

Since the forest surrounding Homosassa Springs was already teeming with wildlife, the Norris Development folks quickly established nature trails to go along with the attraction's underwater features.

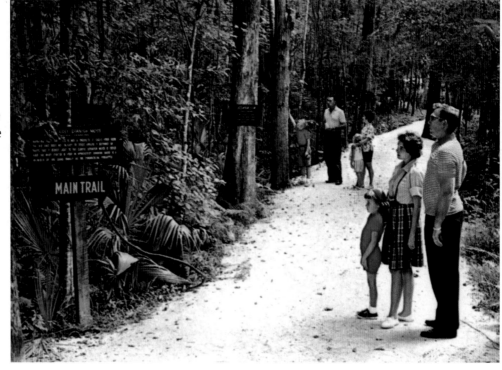

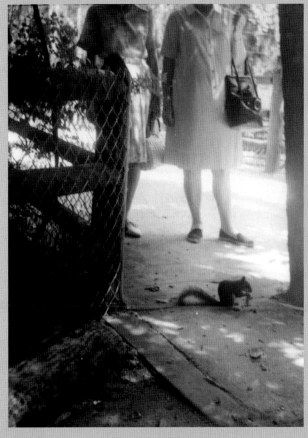

Much publicity was given to Homosassa Springs's tame squirrels, which would eat from guests' hands. This practice eventually had to be stopped because the fuzzy-tailed rodents became so spoiled that they turned from cuties into little pests, aggressively attacking those who did not immediately offer food to them.

The "barrel of monkeys" on Homosassa's pontoon boat ride also reacted much as human brats would if given everything without any effort on their part. They eventually had to be taken off public display because they became so obnoxious.

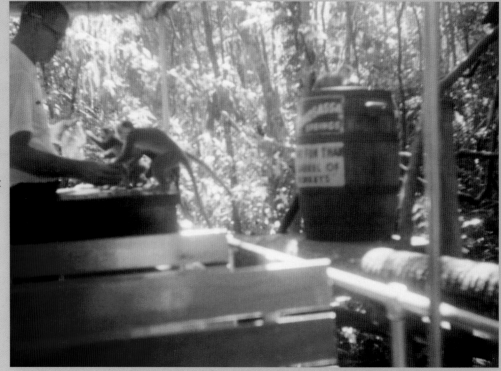

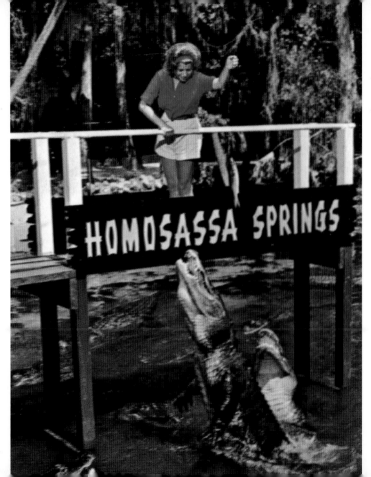

Spoiling squirrels and monkeys with hand-outs was one thing, but no one wanted the alligators to start coming after anyone they thought might be a potential food source. Still, their daily feedings were a popular topic for photos and postcards.

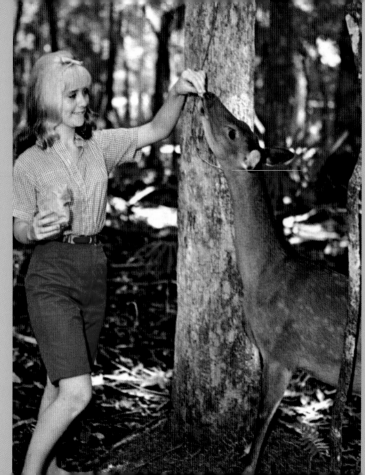

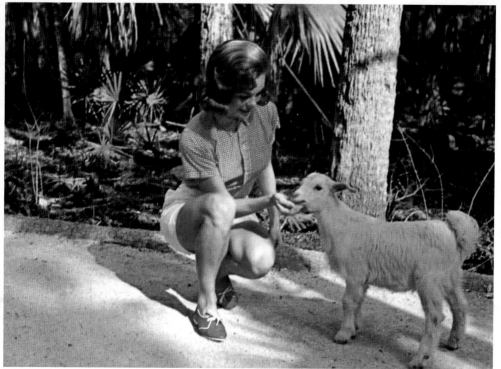

Homosassa Springs, like all the others, used attractive models even in addition to the mini-skirted Native American princesses and Melody May. Combining pretty girls with cute animals was a sure-fire way to get visitors through the turnstile.

Shouldn't this photo be used on a Mother's Day card? Homosassa's Orchid Garden used a matronly lady in an apparent effort to break up the monotony of one young model after another.

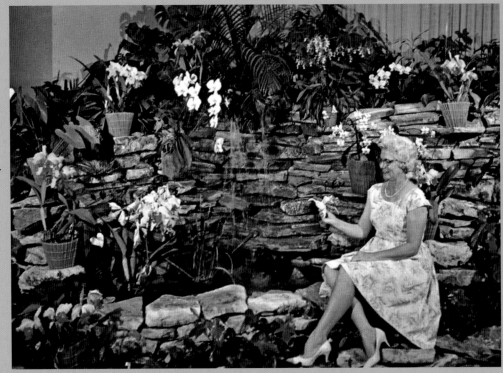

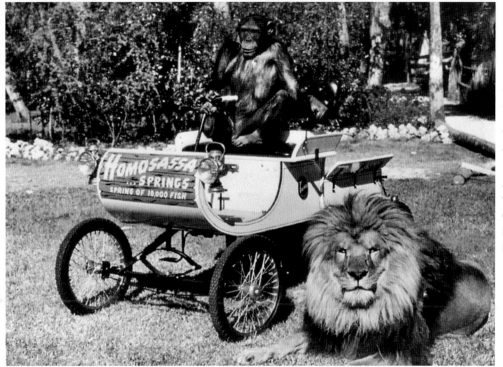

In the 1960s, movie and TV producer Ivan Tors exhibited some of his celebrity animal performers at Homosassa. From the *Daktari* TV series, Clarence the Cross-Eyed Lion was obviously a mane attraction, while Judy the Chimp made her visitors go bananas.

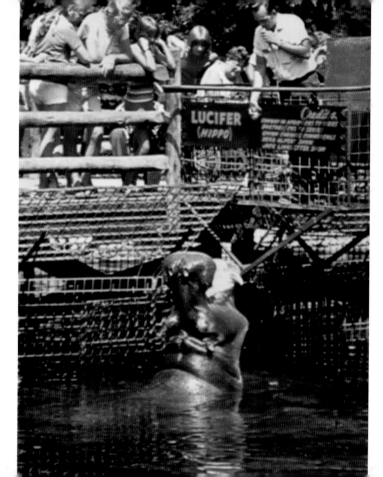

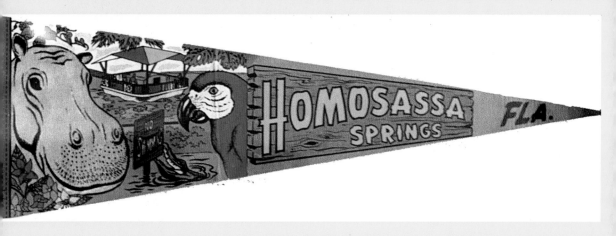

The longest-surviving former Ivan Tors performer at Homosassa was Lucifer the Hippo, who was declared an official citizen of Florida by the governor. Lu, as he was known, made it into the souvenir shop on pennants and bumper stickers.

Between 1978 and 1984, Homosassa Springs went through several ownership changes that sometimes left the facilities in a shabby condition. Finally, Citrus County purchased the property and temporarily changed its name to Nature World.

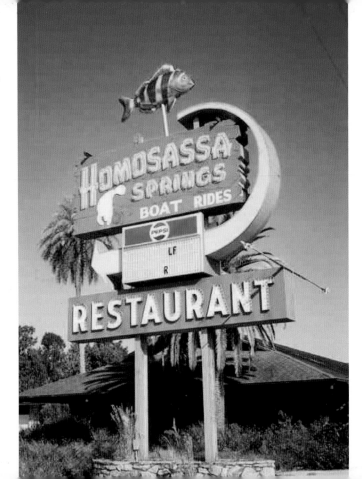

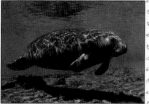

Photographs © Kim Stanberry

The State of Florida eventually took over Homosassa Springs as a state park on New Year's Day 1989. The emphasis would continue to be on wildlife, including the rescue and rehabilitation of the unique Florida manatees.

Homosassa Springs State Wildlife Park is a showcase for native Florida wildlife offering visitors a rare opportunity to observe these animals, birds and plants in their natural setting. Fascinating educational programs are offered daily on West Indian manatees, alligators, crocodiles, Florida snakes and other wildlife. A huge spring, from which millions of gallons of fresh clear water bubbles every hour, is the centerpiece of this 166-acre park and is the headwater of the Homosassa River. ■ Visitors can stroll along unspoiled nature trails and see

deer, bear, bobcats, otters and cougars at close range. ■ Many varieties of birds, from colorful wood ducks, and flamingos to majestic birds of prey, herons and egrets, also make Homosassa Springs their home. ■ Our Children's Education Center allows visitors to have a hands on experience.

Florida State Parks. *the Real Florida*

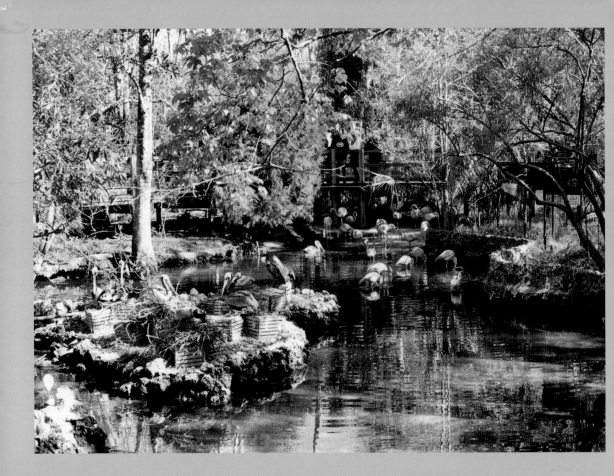

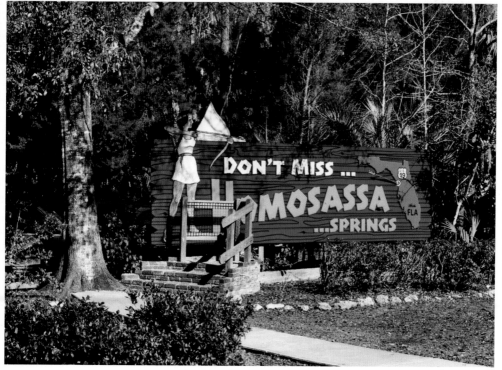

Today's Homosassa Springs State Wildlife Park features the same beautiful vistas, and many of the same types of animals, as it has for decades. Even one of the "princess" billboards has been re-created next to the parking lot to remind people of a bygone era of Florida roadside advertising.

About the Author

Tim Hollis is the author of twenty-seven books chronicling various aspects of popular culture and history, including *Toons in Toyland: The Story of Cartoon Character Merchandise, Selling the Sunshine State: A Celebration of Florida Tourism Advertising, The Minibook of Minigolf,* and *Mouse Tracks: The Story of Walt Disney Records.*